TRaNSLatiON

Traditional and Contemporary Prints by Rhea Nowak
September 10–October 28, 2012
Martin-Mullen Gallery
State University of New York at Oneonta

For Theresa — thanks for being an inspiration. all my best, Rhea

2 Translation

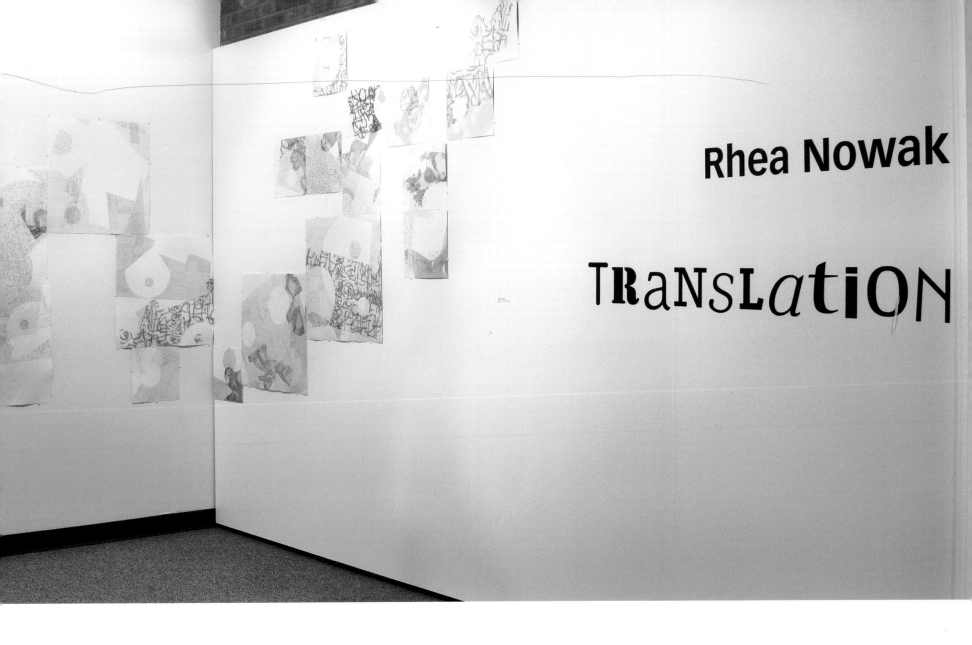

Rhea Nowak

TRaNSLatiON

In memoriam

Lionel A. Nowak

1932–2009

Acknowledgements

This catalog is the documentation of my exhibition *Translation* that was on view at the Martin-Mullen Gallery on the SUNY Oneonta campus in Oneonta NY in the fall of 2012. Mounting this exhibition and putting together the catalog have been collaborative endeavors and there are a number of people I would like to thank for their invaluable help. First, thank you to the Elizabeth Firestone Graham Foundation for the generous grant that made this catalog possible. Thank you to Tim Sheesley, Director of the Martin-Mullen Gallery, for his creative approaches to installation and willingness to do the extra work those approaches entail, to Lee Pfiel for his patient, cheerful and detail oriented assistance with documentation and in hanging the over 160 prints this exhibition included. David Kenny's attention to detail in photographing the work and his unfailing energy and enthusiasm were inspiring to work with. Alicia Opela, who when designing this catalog was a senior at Oneonta, became a trusted colleague and collaborator. Her dedication to its success is very much appreciated. Professor Katherine Spitzhoff generously guided Alicia and me with her extensive knowledge of and experience with graphic design.

I have the privilege of working with many dedicated faculty and staff at Oneonta State College. Thank you to Diana Moseman of the Teaching, Learning and Technology Center for her digital printing expertise and for answering my many questions. Dr. Allen Farber and Professors Nancy Callahan, June Tyler, and Thomas Sakoulas have been especially supportive of me as a teacher, artist and colleague. Your wisdom and company is very much appreciated. Thank you to the Hartwick College Art Department for allowing me to use their Printmaking studio when there was a scheduling pinch.

My sincere gratitude to Linda Heuman for her time, expertise and thoughtful questions. Conversations with you are always a revelation. Thank you to Curator Mary Murray for taking the time to speak with me, look closely and for her articulated insights in to and support of my work.

And thank you to Tim Ploss, Director of the Richards Ave Artist-in-Residence Program. Your company in this project and in the larger one of Life makes all the difference.

Rhea Nowak

photo credit Timothy Ploss

Rhea Nowak

TRaNsLatioN

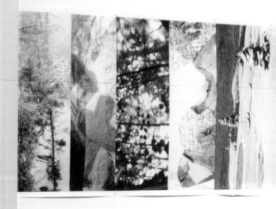

CONTENTS

RHEA NOWAK: TRANSLATION

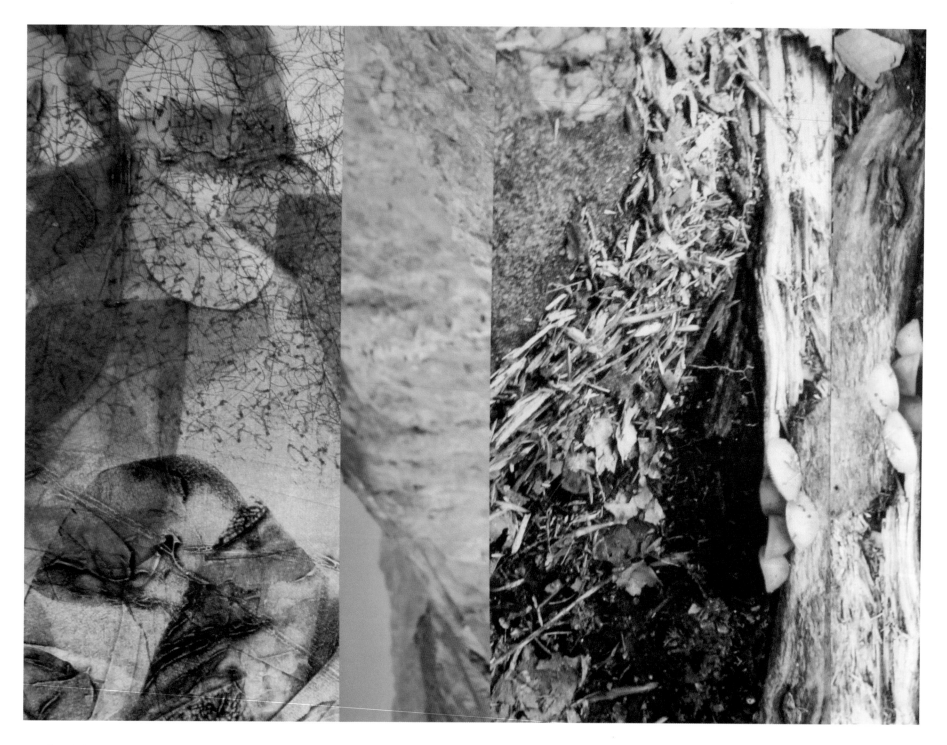

12 detail from *Minding the Gap*

Rhea Nowak's fall 2012 exhibition at the Martin-Mullen Gallery, *Translation*, is an experience in abundance. Her artistic practice embraces multiple forms of printmaking, or image-making in multiples, and here, her images multiply from one series to the next in rich and thought-provoking transformations. Nowak could be described as a traditionalist who loves etching and the printed mark, and she has a serious body of artist's books in her oeuvre. Parallel to paper, plates and press is her photography. More recently, though, tradition and media expand as Nowak introduces digitization into her practice. This enables her to translate quickly her images from one format to another, from one series into another. For Nowak, digitization has lifted restrictions and she clearly has experienced a release that excites her.

Nowak's electric, energized inspiration is manifest in *Translation*. On view are her syntheses of traditional and new printing technologies through four recent series—*Minding the Gap, sum of the parts, Come Close, Go Far,* and *Transference*. Here her images and the marks that comprise them disperse into patterns of variation: select an image, isolate a mark within the image, examine its structure, its component parts, and carry it in a converted state into another composition. How is it transformed? Does the new context change meaning? What translation has taken place? *Translation* is an orchestration of visual relationships between the quartet of projects.

Minding the Gap and *sum of the parts* are concurrent series, both of which unfold in visual succession. The former expands as a long frieze; the format suggests a narrative to be read from left to right. *Minding the Gap* has aesthetic ties to Asian screens and scrolls and is a close cousin to Nowak's accordion books, such as *Sotto Voce*, of recent vintage. It also invites the viewer into an immersive experience. Visually it is comprised of a sequence of Nowak's printed imagery in combination with her own digitally manipulated nature-based photographs that she has cropped, inverted, and beauti-

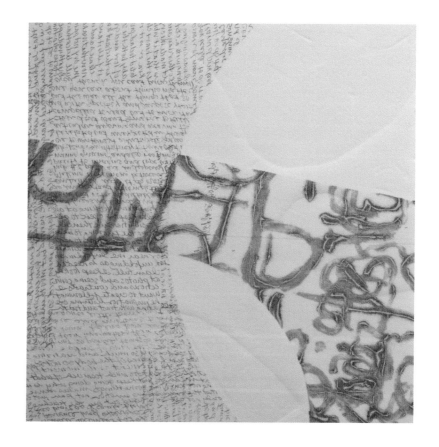

14 details from *sum of the parts*

fully reassembled. One finds the juxtaposition of stone and leaves against pools of water, or images of such close range they approach abstraction, and these are in turn relieved by windows of far-reaching vistas.

sum of the parts is similarly related to Nowak's explorations in book arts. It progresses from left to right as a free-flowing, malleable installation of individual collagraph and intaglio prints measuring 22 x 22 inches or 11 x 11 inches (each installation is site-specific and can include any number of prints, from six to eighty). From across the room, it also holds the wall as a mural in mosaic or drawing.

The palette is lyrically subtle. The larger collagraph forms are reminiscent of swirling veils layered in shades of light-copper, sheer ochre, burgundy, lilac, gray and moss green, all undoubtedly derived from the artist's life in rural expanses and enclaves. It is the palette of grasses and wild flowers growing amidst rocks at the edge of a stream.

Individual collagraphs have curving forms that flow across the leftward-expanding field. The marks are calligraphy of varied weights. The wide line is almost muscular with dimension, and over this is ever-refined script in the spirit of Mark Tobey's white writing. Printed sections are balanced with circles that are left unprinted so that paper simply shimmers.

Because of its palette and flowing forms, *sum* seems light, but intimate exploration reveals the complexity of each print and the intricate interconnections between part to part and components to the whole. *sum of the parts* is about possibilities in change, mixing up the individual elements, and this in the larger sense is the nature of the *Translation* exhibition as a whole, shifting a small etched line, via digitization, into a heroic one in another image.

Come Close, Go Far is one series that looks like two. The small-er-format images juxtapose one of Nowak's photographs, as a photo-etching, with a traditional line etching. These are printed on

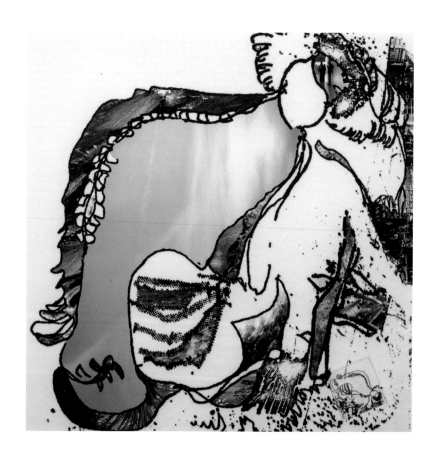
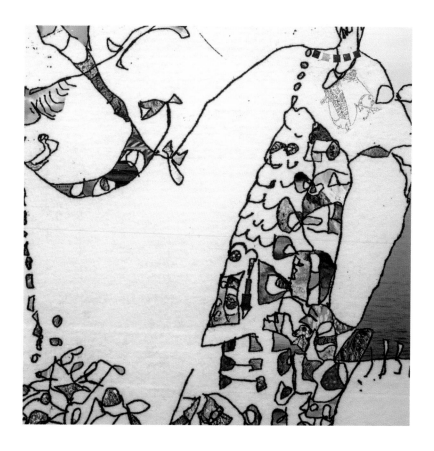

16 *Corners and Edges* and *Kites and Anchors* from the *Come Close, Go Far* series

square paper, 11 ¼ x 11 ¼ inches, with the images themselves a petite 3 x 3 inches. The photographs include large antlers and the skull of a buck; the latch of a weathered wooden door; trees; shadow patterns of branches; and farm equipment in the snow. The strong graphic quality of these images lends itself to translation into the play of black marks on white-paper ground of the etchings with which they are partnered.

If *Minding the Gap* and *sum of the parts* draw the viewer into an embrace from afar (then surprise with details upon close inspection), the small-format *Come Close, Go Far* prints immediately demand intimacy that, in turn, begs questions: What is paired here and why or, what are the implications of joined images, one photograph to one hand-drawn etching? Is one generative of the other? Are these unions, comparisons, potential contrasts, or some combination thereof? And how do the pairs relate to others in the series? In keeping with the extended theme of the *Translation* exhibition, it is helpful to think of the pairs in quiet conversation. Nowak describes her working method as fluid, one image speaking to another, igniting new ideas between the two.

At nearly twice the size, the larger-format *Come Close, Go Far* images are colorful and brash in comparison to their small-format relations. Nowak scanned the smaller-format images and enlarged them in Photoshop, and reintegrated digital photographs. The small etchings are then printed on the large digital prints, integrating their origins. In the larger images, all source material is united into one composition; etched lines are integrated with photographs that become bright windows in an experience similar to one in *Minding the Gap*. Throughout there is a balance between flat patterning and illusionistic landscape space.

The series title, *Come Close, Go Far*, is rich in meaning. In the large-format works, we may find a familiar image, shape or line from the small-format prints, but now they are writ large. Nowak delights in the visual exchanges between the two formats, enjoys the heroic transformation of a simple etched line from the smaller into a

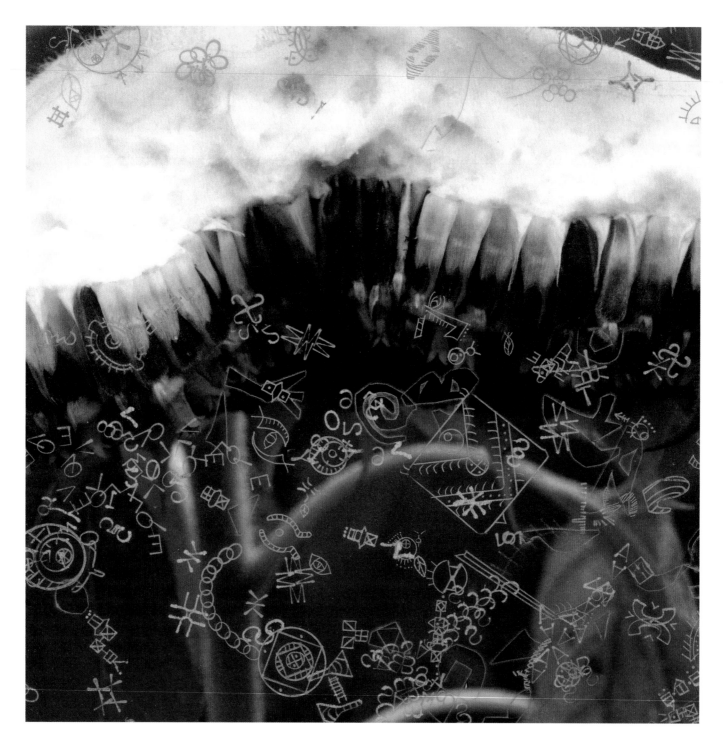

18 *Operator* from the *Transference* series

dominant form in the large. The smaller-format pairs are meditative as prayer cards and the larger format seem all open, outdoor adventure.

Nowak's most recent series is *Transference*, which she discusses as a work in progress. Here she has created ink-jet photographs on which symbolic language is etched. This symbolic language is a further exploration of rawer mark-making in *Come Close, Go Far* and the calligraphic meandering lines of *sum of the parts*. Like the other series, *Transference* is presented with implications of reading, although here the prints are mounted on the wall in a grid, so that cross-referencing between imagery is a lively outcome.

In *Transference* the relationship between her photographs and written language create provocative juxtapositions. In one instance, streambed rocks are imprinted with sgraffito that resembles ancient petroglyphs. Elsewhere the play between form and text undermines clear figure-ground relationships, as the expected three-dimensional illusion of a landscape photograph competes with the very flat printed language.

Translation is an experience of overflowing communication, of languages that cannot be contained. In this exhibition Nowak articulates her desire for making connections between the media and series with which she works as a means to articulate paths to new understanding. We are invited to look and read, even listen, to the conversations that transpire between these works of art and come to understanding about marks, symbols, and languages with which we engage. Or, as Nowak observes: "It is in spending time getting to know a person, delving deep into a subject, or practicing a skill—it is in getting up close—that we go farther and grow as individuals and expand our world."

© 2013 Mary E. Murray
Curator of Modern and Contemporary Art
Museum of Art
Munson Williams Proctor Arts Institute

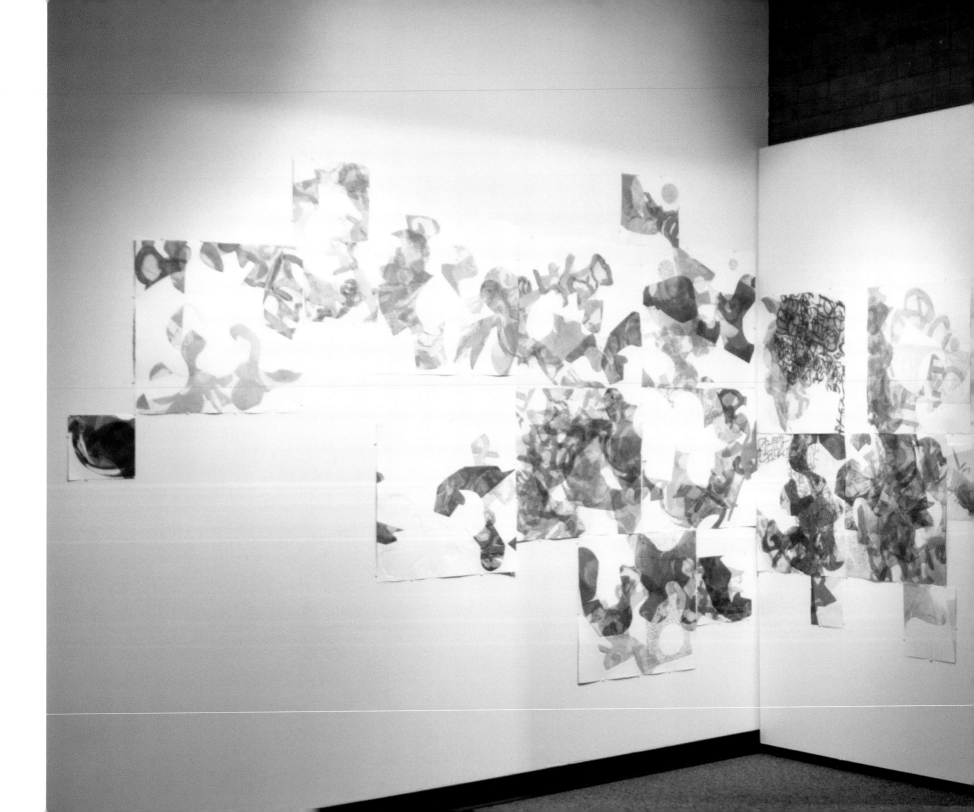

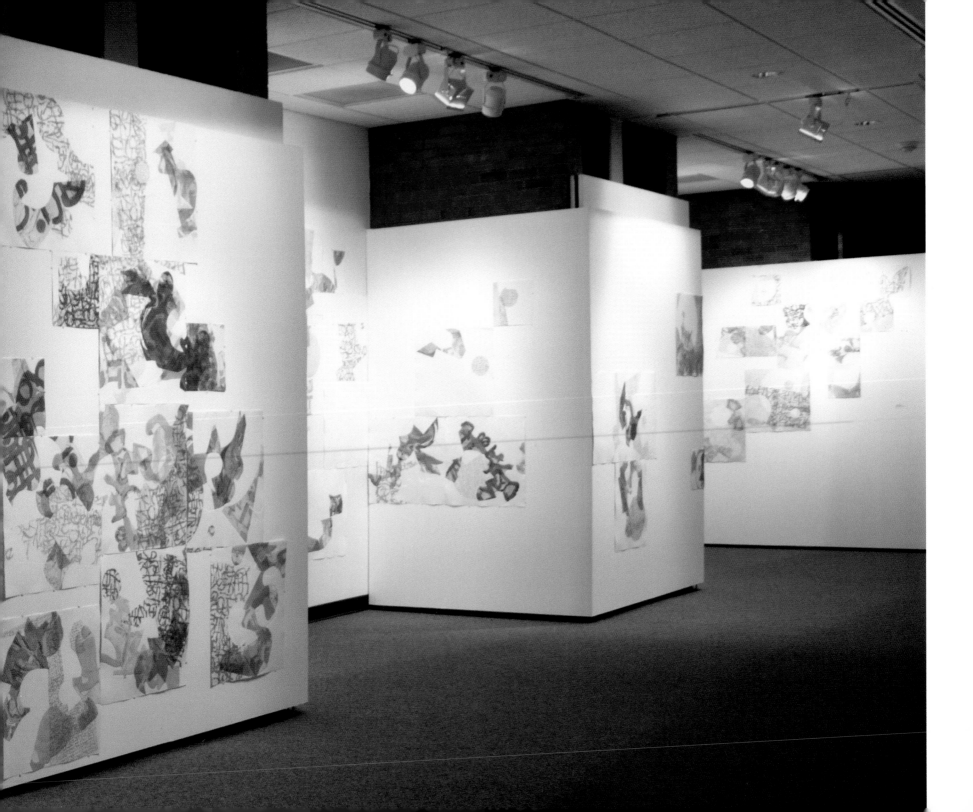

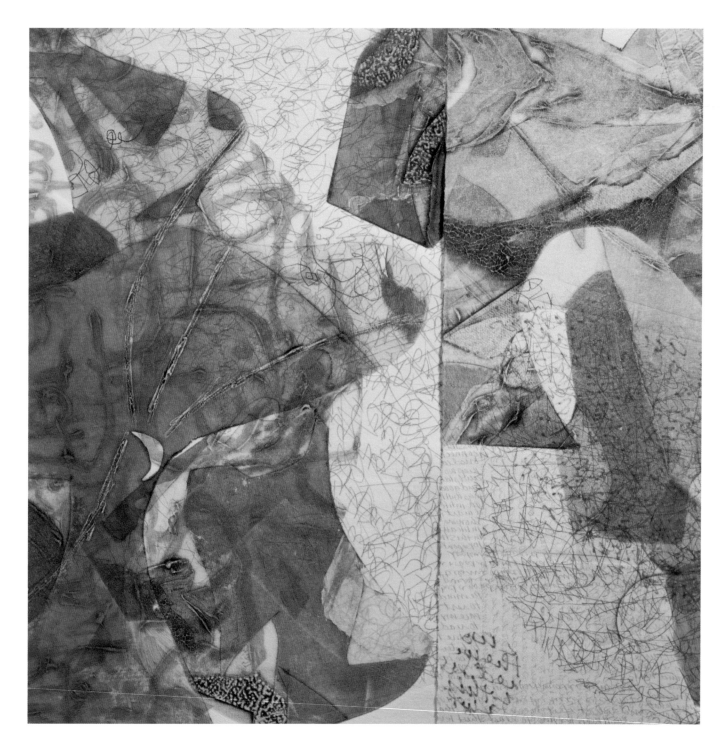

22 This and previous page details of *sum of the parts*

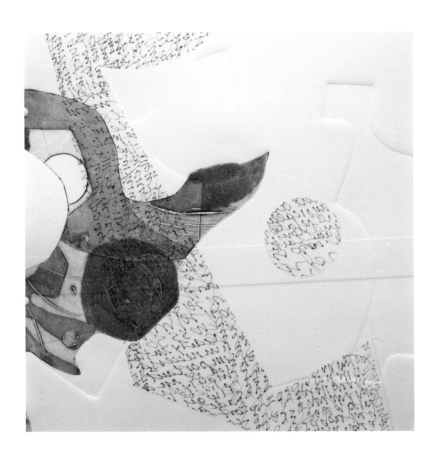

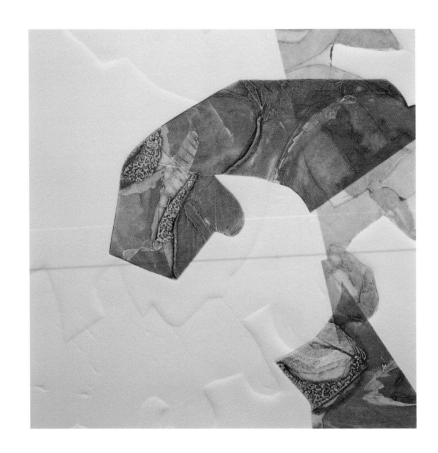

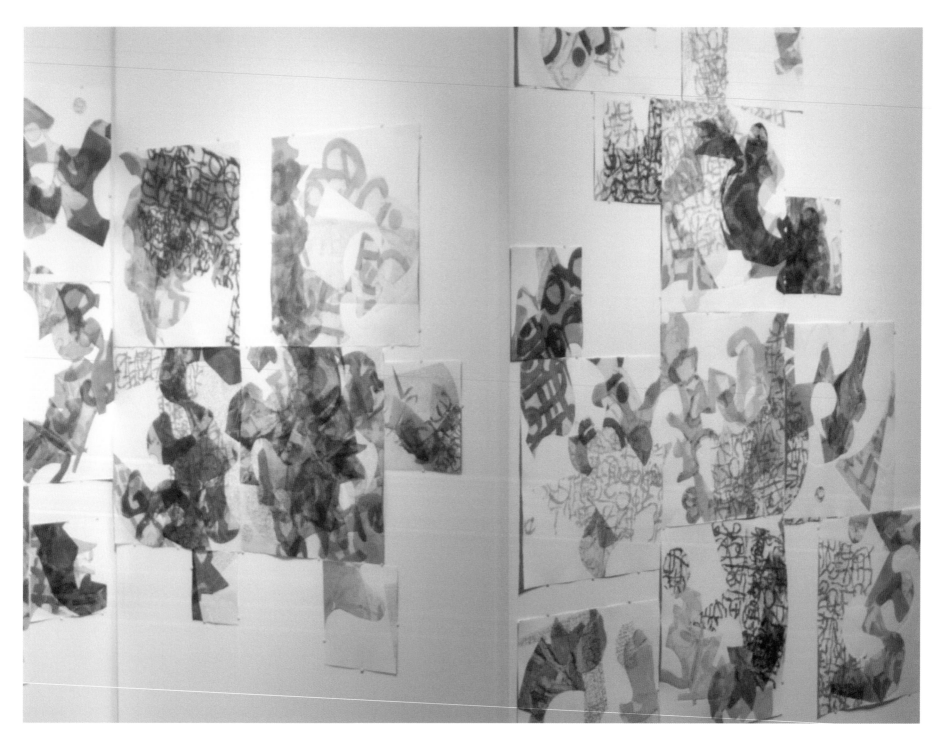

24 details from *sum of the parts*

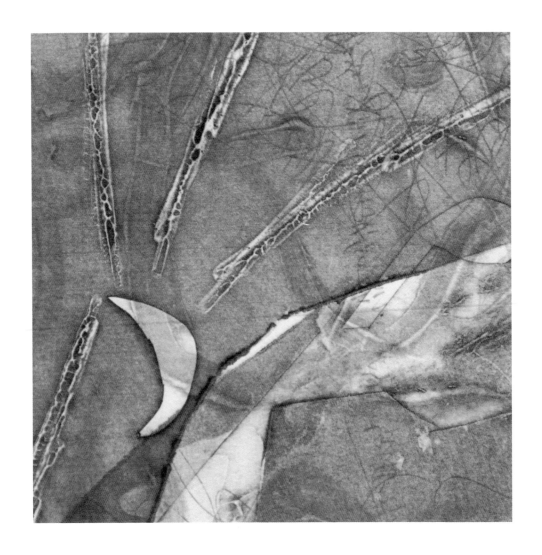

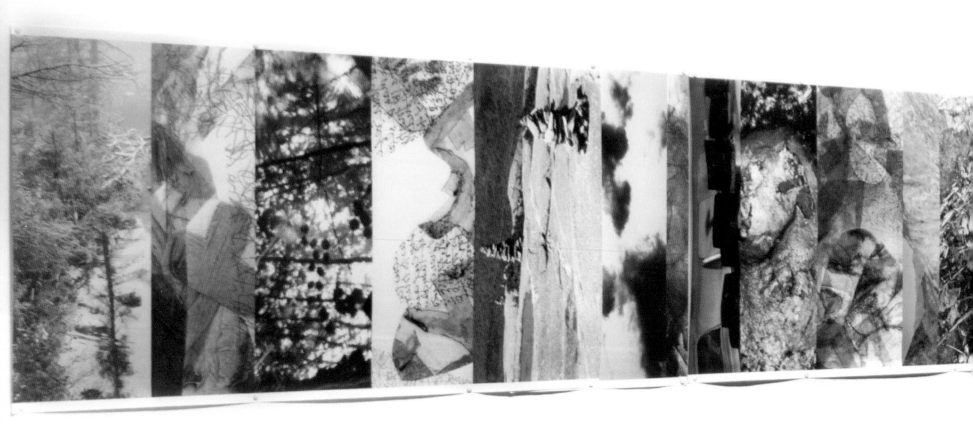

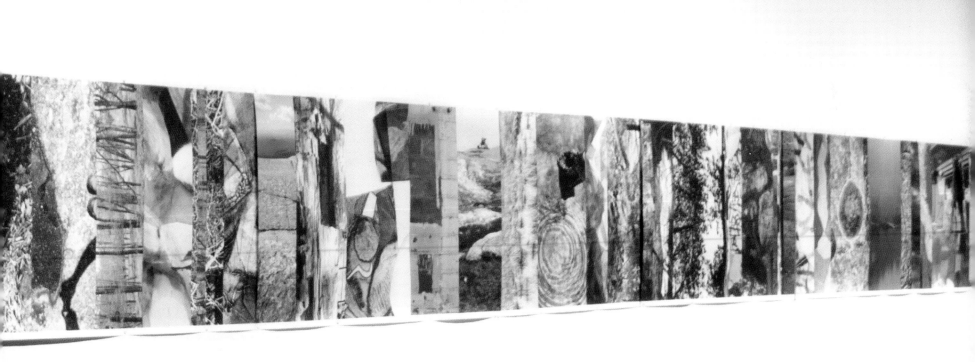

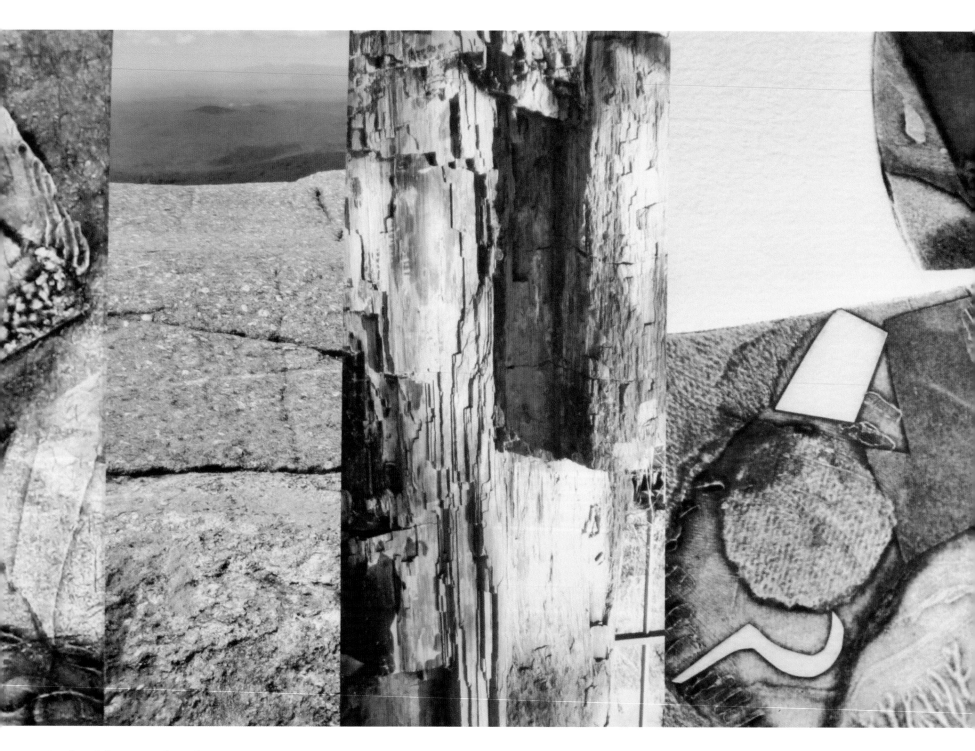

28 detail from *Minding the Gap*

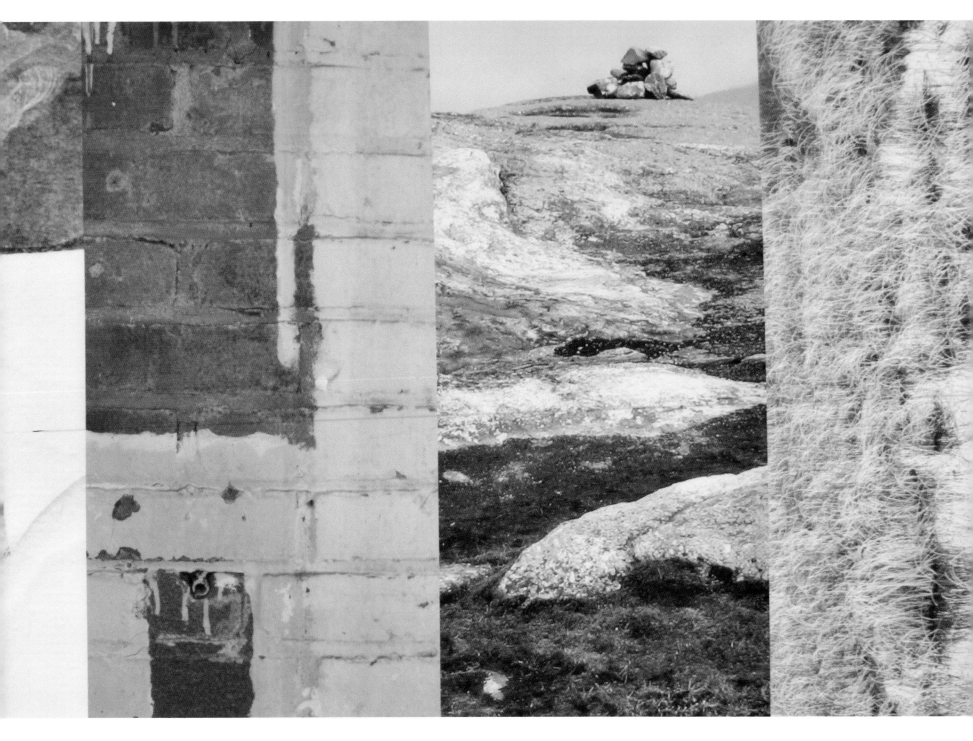

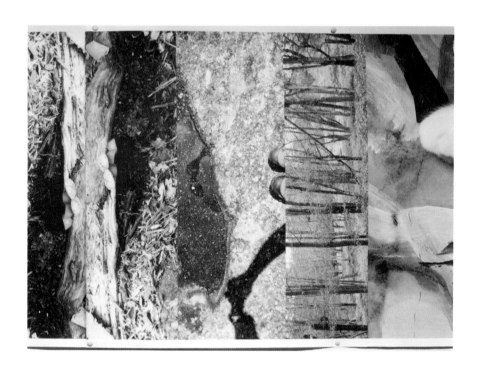

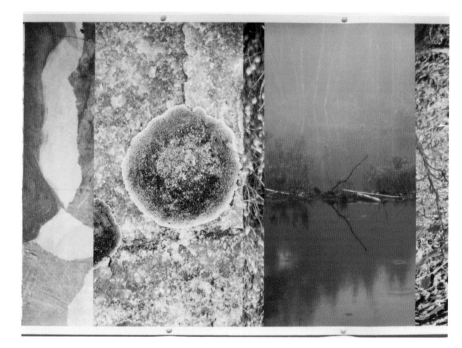

30 details from *Minding the Gap*

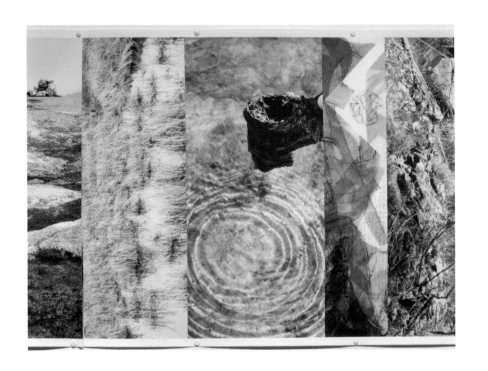
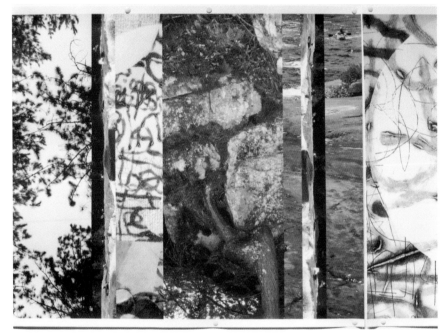

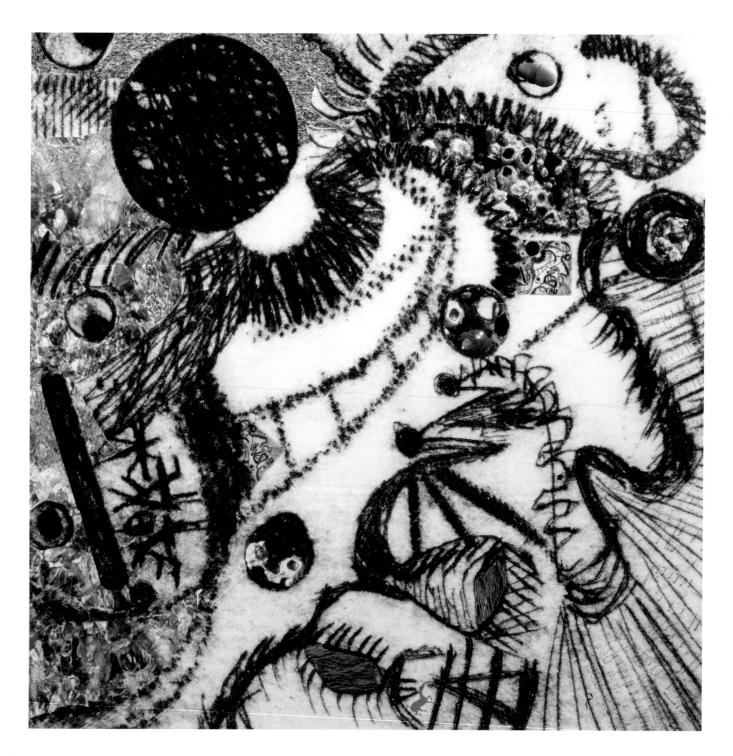

32 *Muse* from the *Come Close, Go Far* series

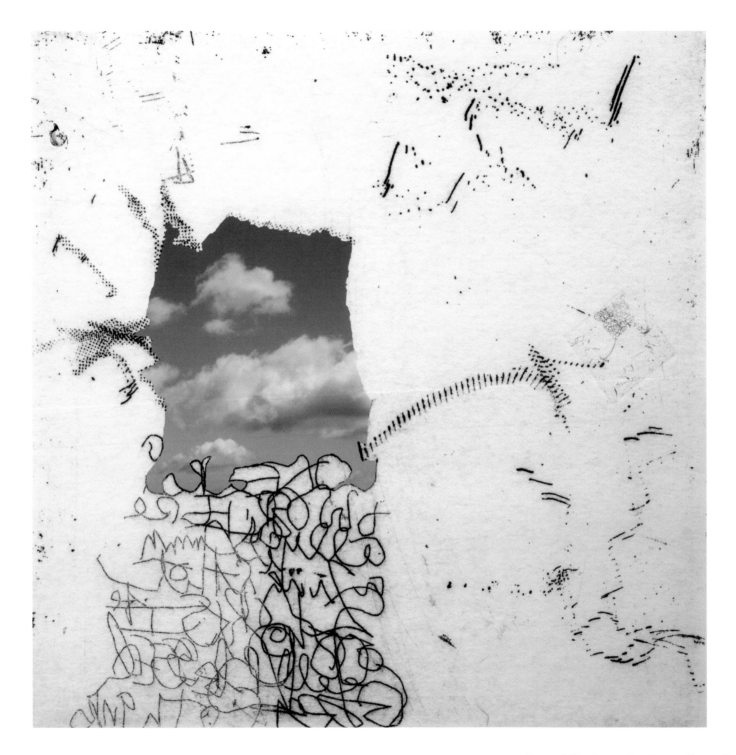

Box of Sky from the *Come Close, Go Far* series 33

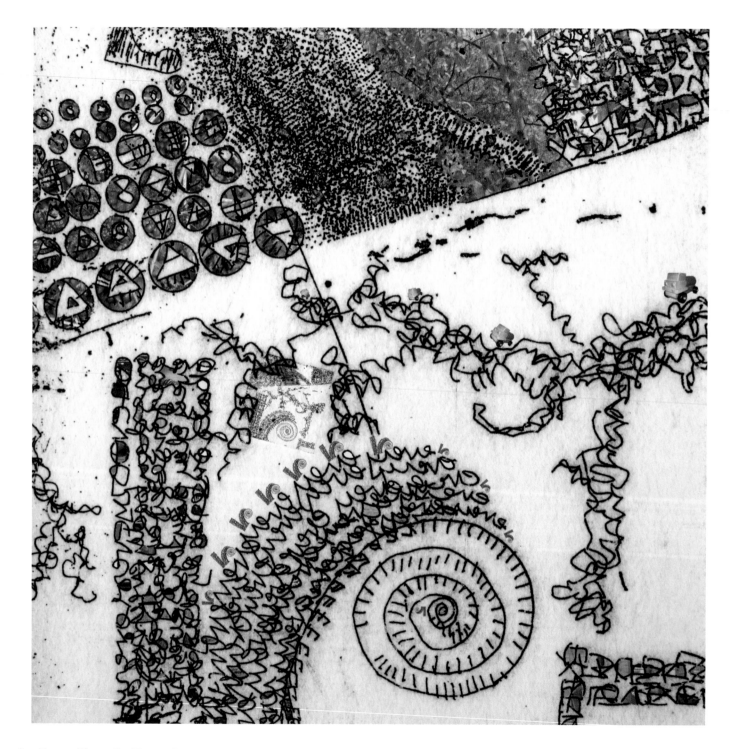

34 *Amaze* from the *Come Close, Go Far* series

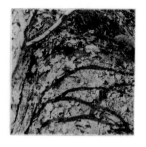 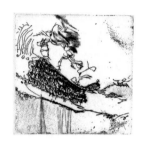 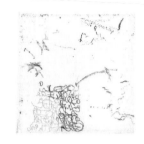 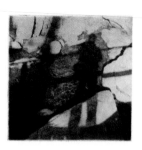

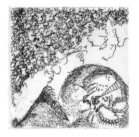 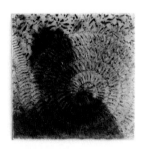 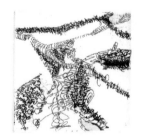

36 *Affinity, Grace, Code Access,* and *Perenial* from the *Come Close, Go Far* series

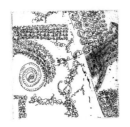 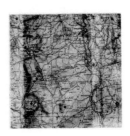

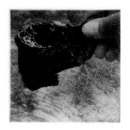 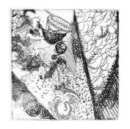

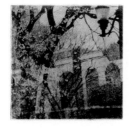 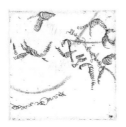

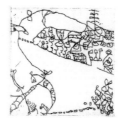

Location, Sift, Passing Through, and *You Are Here* from the *Come Close, Go Far* series 37

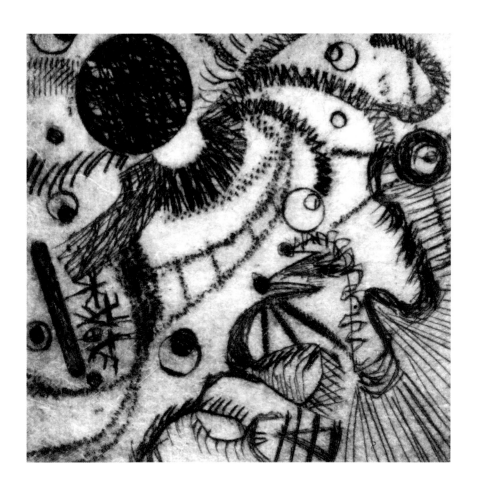

38 details from the *Come Close, Go Far* series

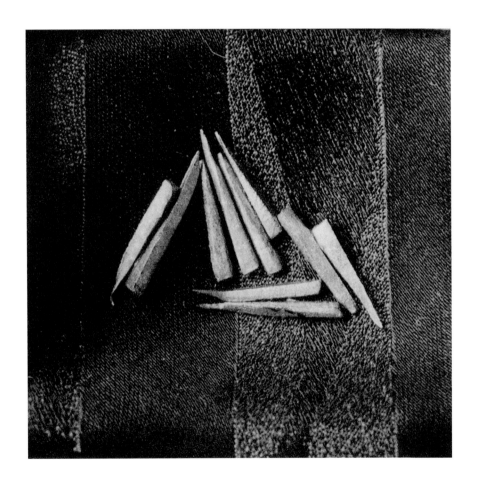

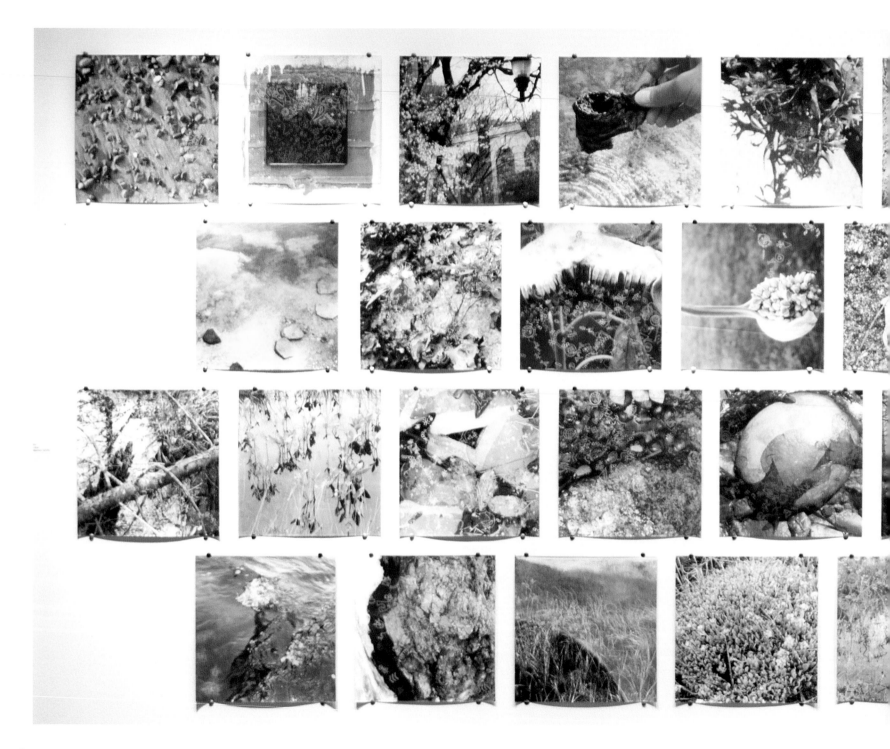

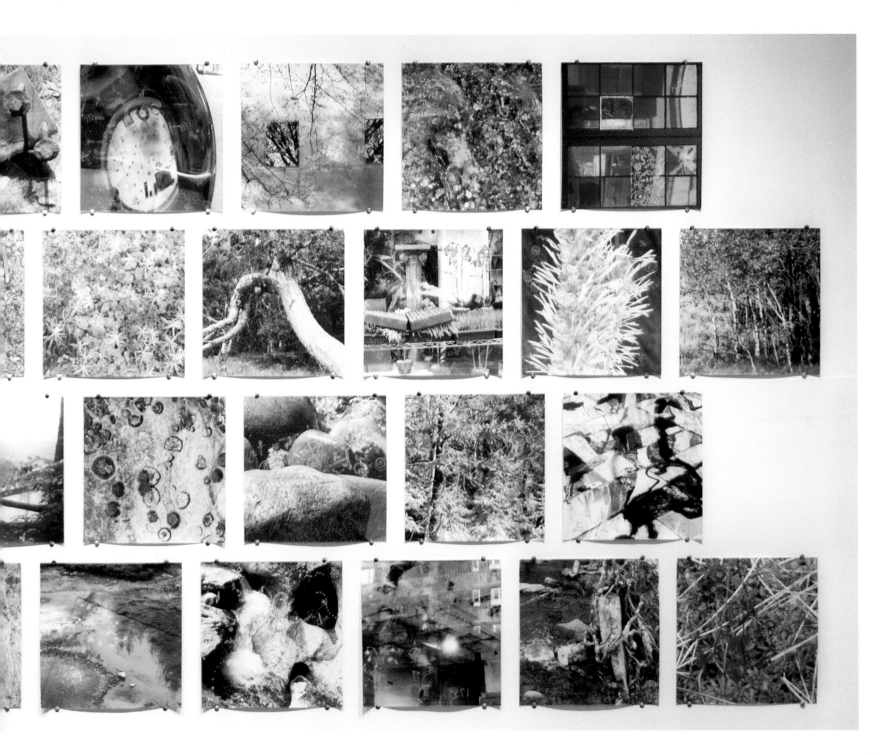

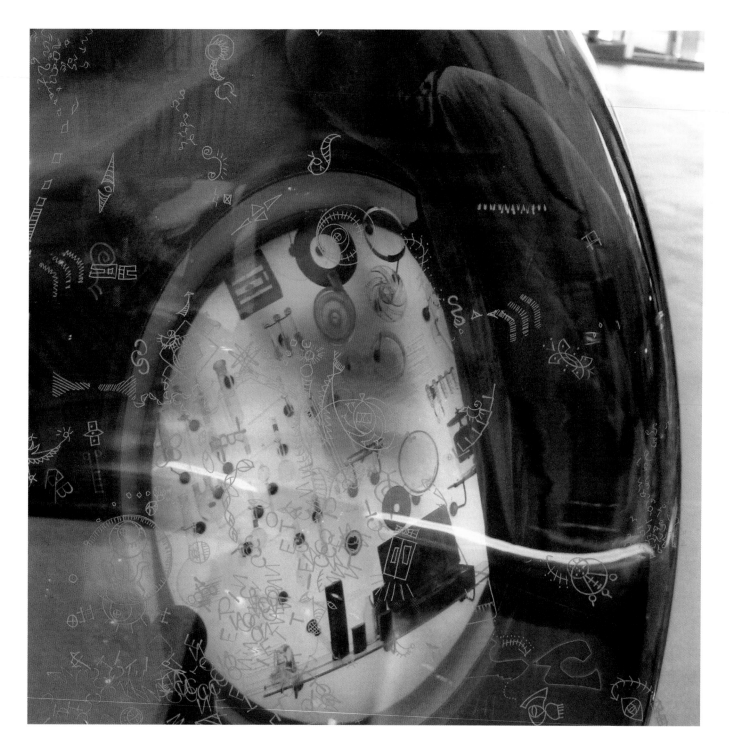

42 *Visit* from the *Transference* series

There and *Attitude* from the *Transference* series 43

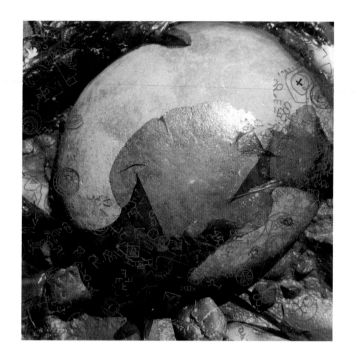
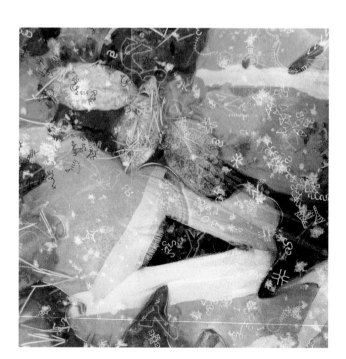
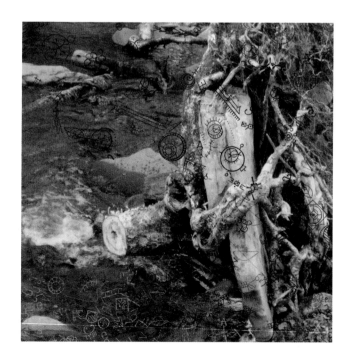

44 *Ride, Here, Ice,* and *Rep* from the *Transference* series

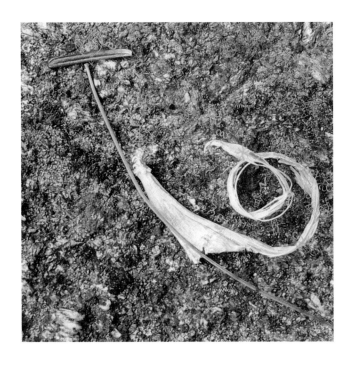

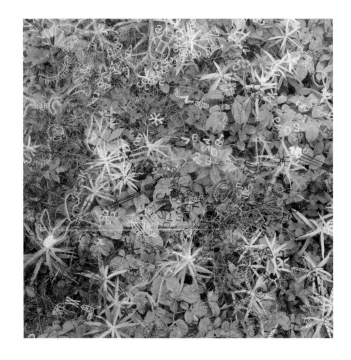

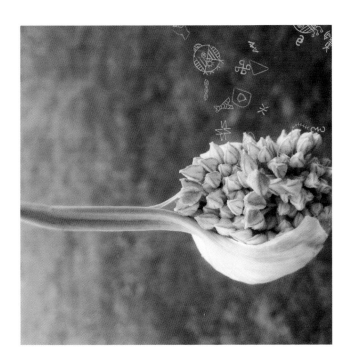

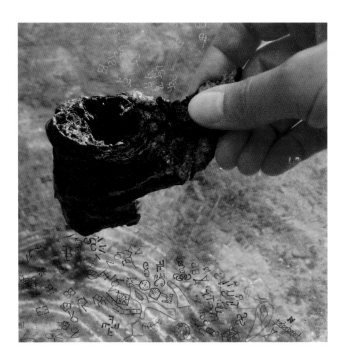

Handle, Bright, Offer, and *Filter* from the *Transference* series 45

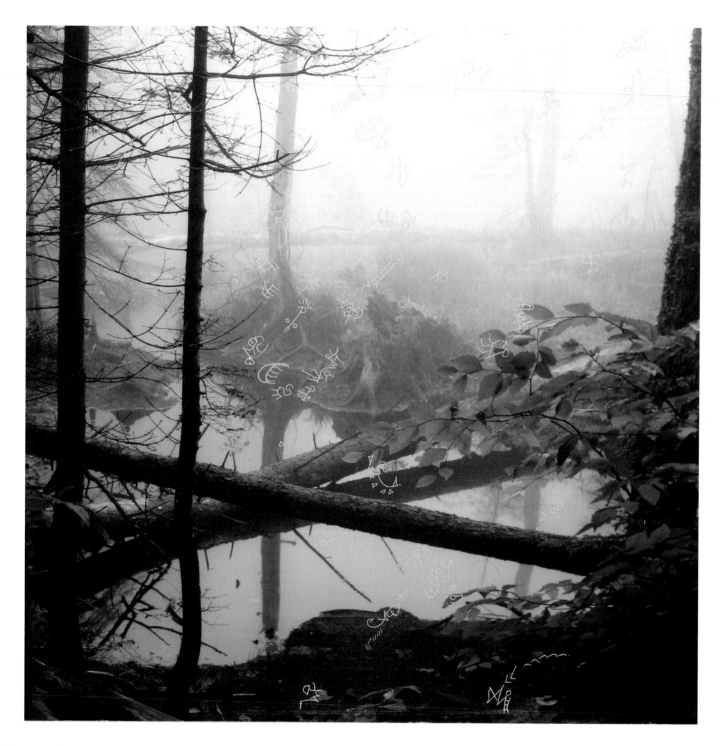

46 *Quiet* from the *Transference* series

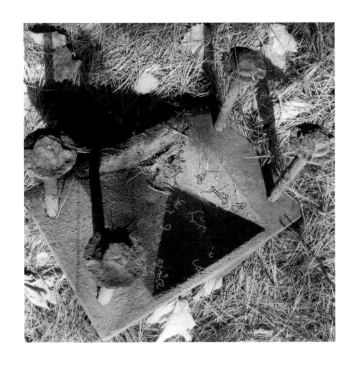

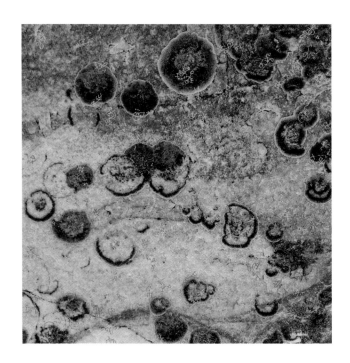

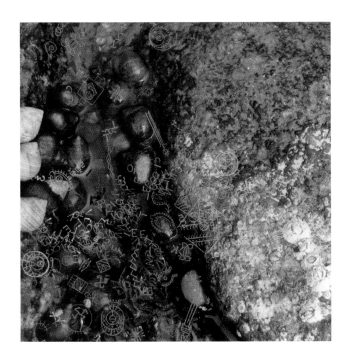

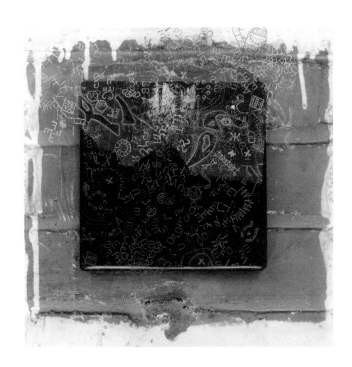

Angle, Sign, Parameter, and *Remake* from the *Transference* series 47

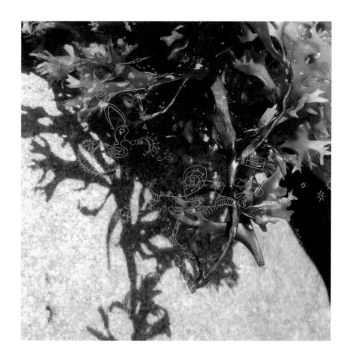

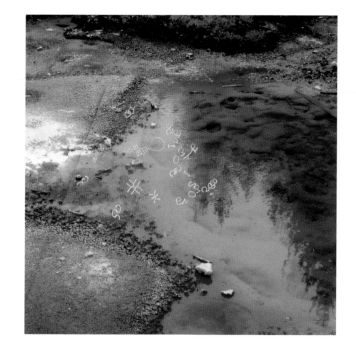

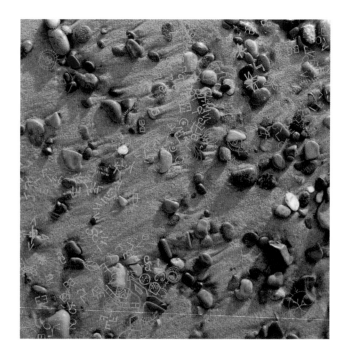

48 *Warmer, Slip, Jewels,* and *Hush* from the *Transference* series

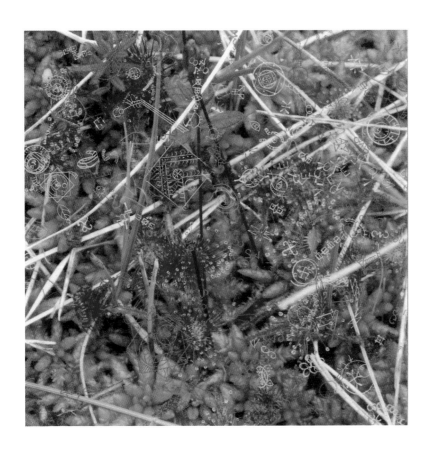 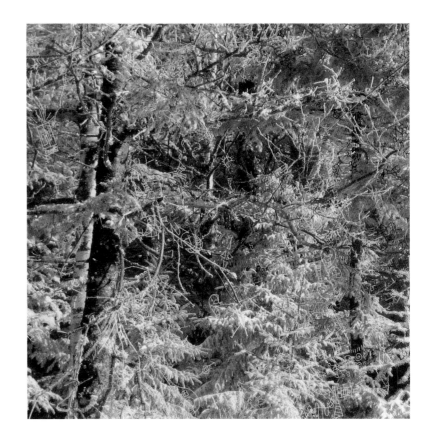

Keen and *Crisp* from the *Transference* series 49

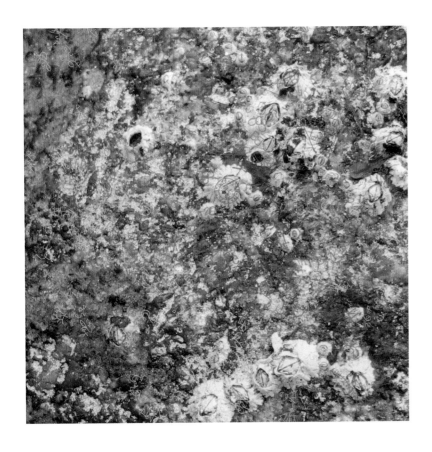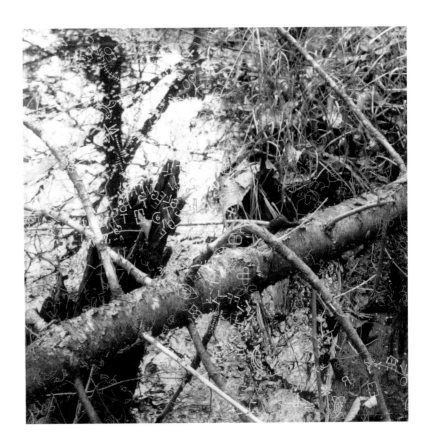

50 *Street* and *Fall* from the *Transference* series

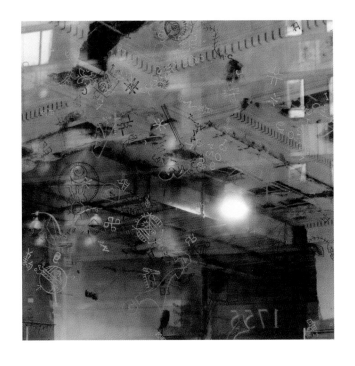 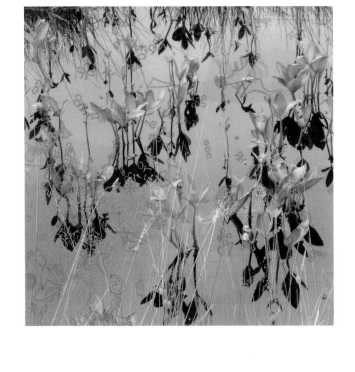

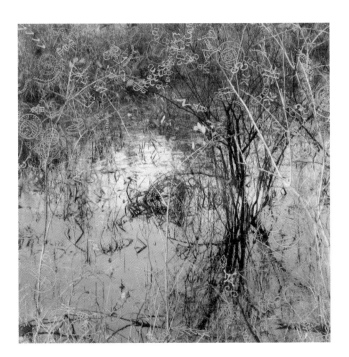 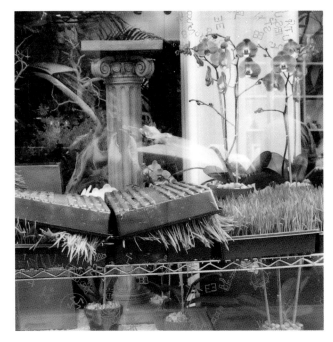

Across, Twin, Fluid, and *Coming and Going* from the *Transference* series 51

A CONVERSATION WITH RHEA NOWAK AND LINDA HEUMAN

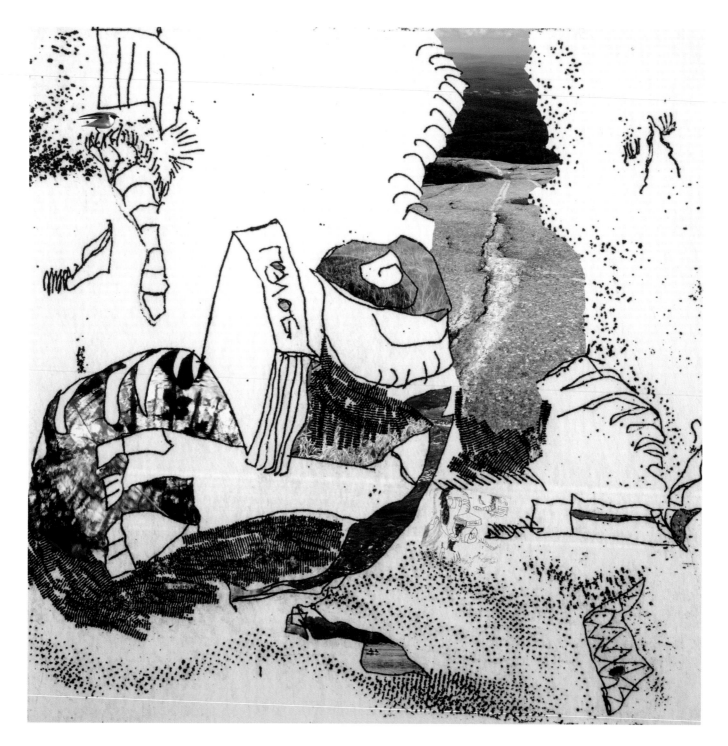

54 *Read to Me* from the *Come Close, Go Far* series

L: The title of your show is Translation. What is getting translated?

R: What is getting translated is the meanings of images. Translation can mean changing an image's context. For example, I take a photograph of a glass doorknob—without the whole doorknob and without the door—and it becomes a circle that has light in it. Then I put it next to a lot of other circles and draw in some marks. It looks like it is falling or turning or wheel-like, and it makes all sorts of other associations. What it really is a doorknob, which does turn, but it doesn't fall through space like it does here. Images can become abstract or really change their meanings radically when you shift what they are next to. When I put one image next to another, what does it make me think of? What does it remind me of? Context changes the image's meaning, its relationships, and its personality.

One thing that I'm doing is I take a photograph and I print it larger in color and then smaller in black and white. It is exactly the same photograph but it is now different because it has been translated by size and by color. Translation also is shifting a single image or idea between media, such as taking a photograph and doing a drawing from it. The drawing becomes an etching, which I scan and digitize. Then I enlarge it several times and add new elements—other photographs, drawings, or drawings of photographs. Then I print the digital image and run it through an etching press with the original etching plate. So the origins of the image are embedded in its new form.

Are you really talking about 'translation' then? We usually think of translating as lifting something (like meaning) from one context and putting it in another and trying to recreate the *same* thing in another context. For example, when I think of translating, I think of taking a word from one language then trying to find a word that means *the same thing* in another language. Is translation for you about sameness or difference?

Translation to some extent does preserve sameness. When you translate, you are looking for an exact equivalent. But the process of creating this work has led me to believe that such a thing does not exist. It always becomes an approximation, which is why language translation is an art. You have to know both languages

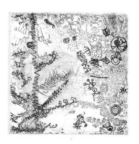

56 *Resighted, True, Change in Time and Place,* and *Size of the World* from the *Come Close, Go Far* series

intimately and you should only ever translate into your own native language, because you cannot translate into something that isn't native to you. It takes incredible skill to do it even in languages where you would think there would be equivalents because context changes things. Time changes things. The person who is speaking changes things.

This is an image-driven world. I use photographs because we are so familiar with them and we think we know what we are looking at. But we don't. I can make the familiar look unfamiliar by cropping it and putting it next to something you don't expect. And now it becomes something else that you are not familiar with. It gives you more; or maybe it takes something away, I don't know—that is the viewer's choice. It is exactly familiar but it is changed. To me that is 'translation.'

In just the same way we can be familiar with a person and think we know them well and yet do we? You can be with someone and an event happens, and because you are two different people, it is two different events in a sense. For example, I'm flying down the hill on my mountain bike—and I'm this big and I weigh this much and I have this experience and I ride the trail this way. And the person who is right behind me on exactly the same trail and also on a mountain bike, who weighs a hundred pounds more, is having a completely different experience because he is wearing a different body. He can't duck under that low branch, because he is too tall; I didn't even see it—I just went under it. I weigh less, so I hit the ground differently when I bounce on my bike. It is a completely different experience. The same one—but it is translated by virtue of it happening to another person standing two feet away. There is a translation there.

It is a question about what creates worlds. As an artist, I'm wondering, what is this world? Scientists ask this as well: Where are we? What are we doing here? What is this? This body of work has taught me—and my work in general has brought me to understand—that we create our worlds through relationships. And those relationships require translation all the time. We are different individuals in different bodies interpreting events with our own set of experiences, so we understand in different ways. And yet we manage to have very complex relation-ships—socially, politically, and culturally—that mostly manage to work. They work because we have faith that that translation is close enough. If you want it to be closer, that's when spending more time with a person, with an idea, with a subject, with a skill, makes all the difference.

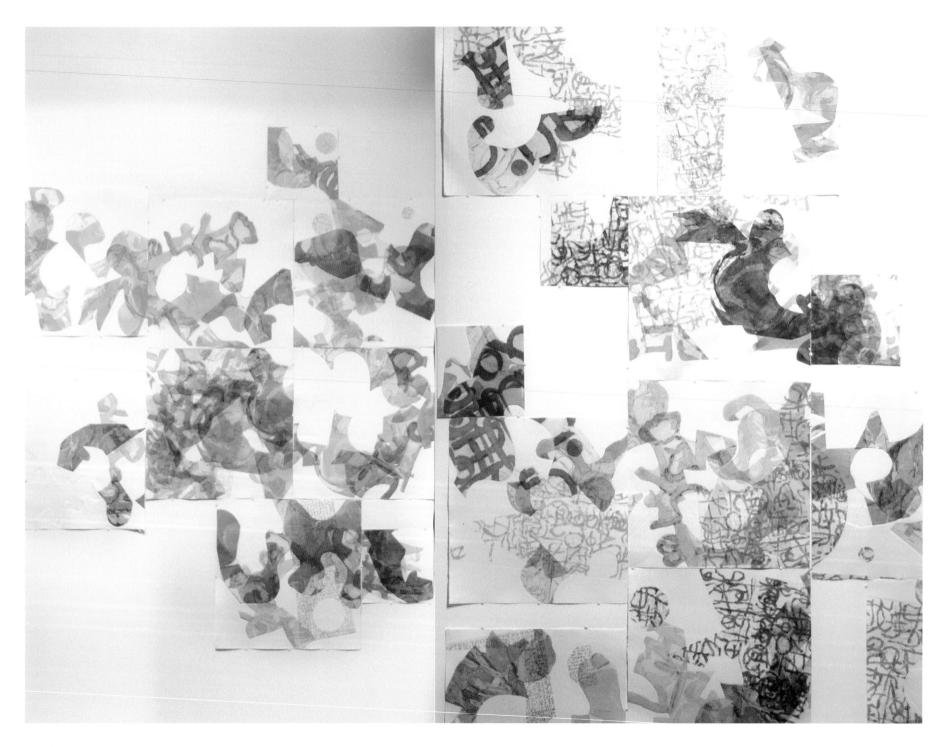

58 detail from *sum of the parts*

It sounds like you are saying that an image is intimately tied to its context. Its context is part of what it *is*.

Nothing, no one, stands on its own. It is always in relation to something or someone else. There are always relationships going on.

My installation *sum of the parts* explores this notion of relationship. (It is 'sum' because the whole is always greater than the sum of the parts.) This installation comprises eighty-six intaglio and collagraph prints: fifty twenty-two inch square; thirty-six that are eleven or six inches square. Any number of them can be arranged in any order and orientation and it is still the same piece. For example, the Newport Museum in Rhode Island said their space was limited to a certain size. So I sent them twelve prints to choose from and they put them up any way they wanted. So it becomes a collaborative process.

So, in a sense it is atomistic. But it isn't really atomistic, because if it were each piece would stand alone and be self-contained. You could maybe put them together and they would make bigger things, which would also be self-contained. But this is somehow different, because the prints only work in relation.

They are about relationship, absolutely. Can they stand as individual prints? Yes, I guess they can, but I don't think that is as interesting. What is interesting to me is all the possible relationships. Each time they get put up again it is a different orientation—the space is different, the light is different. There are lots of prints here. I don't remember how exactly I put them up before. I'm not interested in exactly how I put them up before. I want it to be a new approach, a new set of relationships, a new way of looking, and a new narrative each time it goes up.

This gallery is an interesting space because there are many walls, extending into the center space and connecting back out.

The first time I put this up I didn't have that option. I had one really long high wall and one short wall connected by a corner.

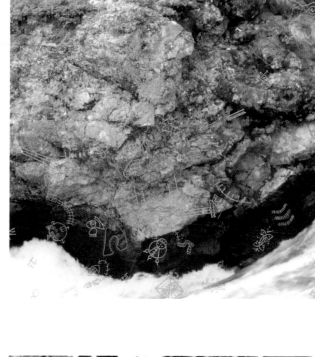

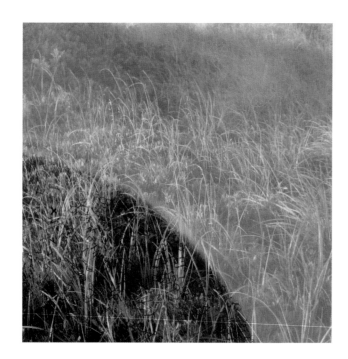

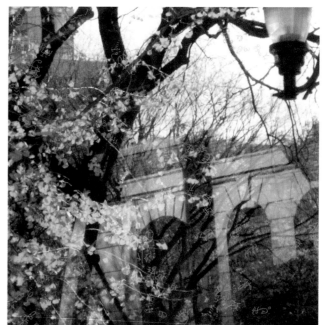

60 *Elder, Rush, Choices* and *Light* from the *Transference* series

So does this shape of the wall change it?

Absolutely! It is totally marvelous. Last time I worked my way out from a corner. This time there were multiple corners to work with. I started somewhere in the middle and made groupings. Then I worked from multiple points to make connections between the groups, depending on what you could see standing at each point of view. I played with the fact that you can't see the installation all at once: it's more like turning the pages of a picture book where you see part of one page as it disappears and then the next one appears. Not only can you not see it all at once but sometimes you see things next to each other that aren't next to each other, actually. And that really interested me. It is building new connections and narratives depending on your point of view.

One of the ideas behind *sum of the parts* is the presence of absence. The absence can be an absence of mark, but still with an embossing, or an absence of both mark and embossing, so it just the plain white of the paper. It is also the spaces between the pieces of paper on the wall. So when I put these together I look at where the print marks make relationships, but I also look where the shapes of the unprinted areas make relationships, because absence has a presence—particularly if it is absence as loss.

That emptiness, that unknown, that space is also really important to an artist. It is the space where the unknown cohabits with the potential. It is that amorphous, strange, you-don't-know-what's-there place. It can be frightening. It can be marvelous. But it is what everything comes from—that no-name, unknown space.

So the space of 'something missing,' which seems negative--(I think of grief when I think of loss)—has a positive side?

I think it can. I think of it as the space where we go when we die and where we come from when we are born. As an artist, I think it is also a really important space—and important to be in that space of not-knowing and to create from that space. It's not always comfortable, but it is really big. There is room there. And being attentive to being in that uncomfortable unknown is really important when you are making things.

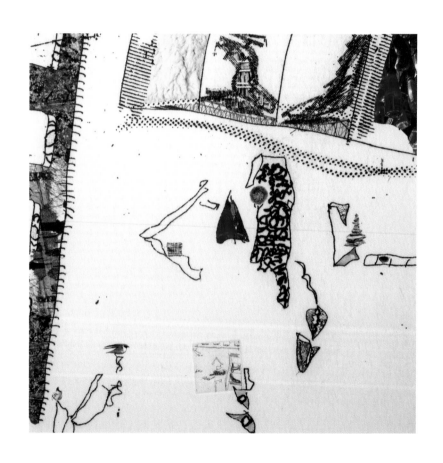 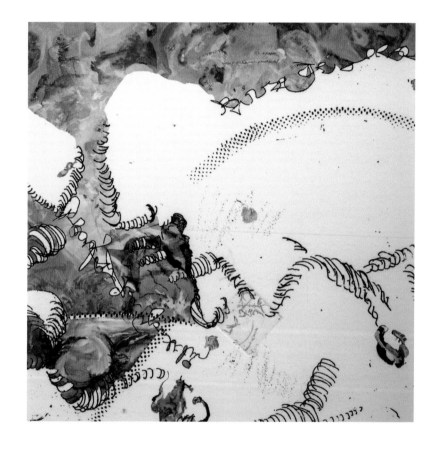

62 *Sensible Things* and *Carry On* from the *Come Close, Go Far* series

Something that really strikes me in this series *Come Close, Go Far* is the repetition of an image like a break or a gap, an interruption, a disruption of uniformity—and a vision of open sky seen through that.

Almost like a window or a doorway into space.

Exactly. For me as a person who meditates, those images remind me of the mind. Ordinarily our minds have one thought after another, but if you pay close attention, there are also gaps between thoughts. In those gaps, a sky-like space can open up. The space is there all the time in the background, but we don't usually experience it because we are so focused on what's in the foreground; we are hemmed in by our thoughts. Every once in a while, though, there is an opening.

I take pictures of skies constantly. I guess it is because I feel like things are crowded. And the sky gives the impression that there is enough room, enough space for everyone and everything. The sky for me is a metaphor of openness. It is a really joyous, exhale kind of openness.

Another kind of openness for me as an artist is the openness of possibility. I look closely no matter where I am. I take an enormous number of photographs and do a lot of drawing. I play with multitudes of images. This multitude that I play with has a sense of potential. It's that creative potential that gives me a feeling of openness.

© 2013 Linda Heuman
Freelance Journalist and Contributing Editor, *Tricycle: The Buddhist Review*

Rhea M. Nowak
rheanowak.com

Education

Master of Fine Arts, Printmaking and Drawing, 2000
University of Connecticut, Storrs CT

Master Printer Certificate, 1989
Il Bisonte, International School of Printmaking, Florence, Italy

Bachelor of Arts, Printmaking and Painting, 1985
Bennington College, Bennington, VT

Solo Exhibitions

2012 *Translation, Traditional and Contemporary Prints by Rhea Nowak*
Martin Mullen Gallery, SUNY College at Oneonta, Oneonta, NY

2010 *sum of the parts, Minding the Gap, Installations by Rhea Nowak*
Lucas Gallery, Experimental Space Gallery
Fairfield University, Fairfield CT

2009 *Pieces of Continuous, Recent Drawings by Rhea Nowak*
Grosvenor Gallery, SUNY Cobleskill, Cobleskill, NY

2008 *Personal Cartography, Recent Work by Rhea Nowak*
Stark Campus Gallery, Kent State University, Canton, OH

2006 *Orienteering, Recent Work by Rhea Nowak*
Tompkins Gallery, Cedar Crest College, Allentown, PA

2005 *Rhea Nowak Books and Prints* Studio Gallery 88, New York, NY

Selected Small Group Exhibitions

2003 *Rhea Nowak and Jan Moreno*
New Space Gallery, Manchester Community College, Manchester, CT

2002 *Making Arrangements: Recent Work by Rhea Nowak and Chris Hutchins*
Windham Area Arts Center Gallery, Willimantic, CT

2000 *The Line, The Family and The Space Chimp-MFA Exhibition*
William Benton Museum of Art, Storrs, CT
Printmaking from the University of Connecticut

1999 *Recent work by Mazzocca, Nowak, Sloan, Smolinski*
Gallery of Contemporary Art, Brzeg, Poland
Public/Private, Part/Whole, Individual/Family

1999 *Work by Filipe Miguel, Rhea Nowak, and Mindy Tucker*
University of Connecticut, West Hartford, CT

1998 *Collage – Chris Hutchins and Rhea Nowak,* Indian Hill Arts, Littleton, MA

1996 *3 on Paper: Harold Lohner, Monice Morenz, Rhea Nowak*
Washington Art Association, Washington Depot, CT

Selected Invitational Group Exhibitions

2012 *Score 2012*, Akus Gallery,
Eastern Connecticut State University, Willimantic, CT

2011 *Micro/Macro*, Newport Art Museum, Newport, RI

2011 *Inklings*, Children's National Medical Center Gallery, Washington D.C.

2011 *Turning the Page: The Evolution of Artists' Books*
Beard and Weil Galleries, Wheaton College, Norton, MA

2010 *Travel +*, Bristol Art Museum, Bristol, RI

2010 *Inked Spirol Gallery*
Quinebaug Valley Community College, Danielson, CT

2009 *Handmade: Paper, Prints, Drawings, Artists Books*
Mural Gallery, Stamford, NY

2008 *Outrageous Pages*, Ingenious Artists' Books,
Fine Arts Gallery, SUNY College at Oneonta, Oneonta, NY

2007 *Cultural Identity Sofia Press Gallery*, Sofia, Bulgaria

2005 *Reflections,* Eastern Connecticut State University, Willimantic, CT

2005 *Printmakers' Network of Southern New England*
Mansion at Strathmore, North Bethesda, MD

2005 *The Progressive Print*, Loomis Chaffee School, Windsor, CT

2002 *Sense/Language*, Eastern Connecticut State University, Willimantic, CT

2000 *Interprint Alsdorfer Kunstverein*, Alsldorf, Germany

1989 *Segni Incisi*, Il Bisonte, Florence, Italy

1985 *50/50*, Monotypes- Prints from the Collection of K. Caraccio
Montgomery College, Rockville, MD

Selected Juried Exhibitions

2013 *63rd Exhibition of Central New York Artists*
 Munson-Williams-Proctor Arts Institute, Utica, NY

2012 Library Science -Pick Two
 Artspace Gallery 5, New Haven, CT

2011 *Threaded*, Kirkland Art Center, Clinton, NY

2010 *New Prints Spring 2010*,
 International Print Center New York, New York, NY

2010 *Fit to be Bound*, The Edge of Art NY State Artists Series
 Everson Museum of Art, Syracuse, NY

2010 *Continuity/Kontinuita Prints from*
 Czech/Slovak American and International Artists
 Rotunda Gallery, University of Nebraska-Lincoln, Lincoln, NE

2009 *Undefined*, Contemporary Printmaking
 Desotorow Gallery, Savannah, GA

2008 *61st Exhibition of Central New York Artists*
 Munson-Williams-Proctor Arts Institute, Utica, NY

2007 *Invitational Exhibition of Painting and Drawing,*
 John Slade Ely House Center for Contemporary Art, New Haven, CT

2007 *The Boston Printmakers 2007,* North American Print Biennial
 808 Gallery, Boston University, Boston, MA

2006 *The Art of Printmaking*, Spring Bull Gallery, Newport, RI

2006 *Drawing 2006*, Kent State University, Stark Campus, Canton, OH

2006 *Paper in Particular*, 27th Annual National Exhibition of
 Works on or of Paper, Columbia College, Columbia, MO

2005 *Cover to Cover*, A National Artist Book Exhibition
 Maryland Federation of Art City Gallery, Baltimore, MD

2005 *Unrehearsed Acts*, Artspace, New Haven, CT

2005 *Tact Tiled Lines*, Hygienic Art Galleries, New London, CT

2005, 2004, 2003, 2001 Parkside National Small Print Exhibition
 University Of Wisconsin-Parkside, Kenosha, WI

2003 *NorthEast Prints 2003*, William Patterson University, Wayne, NJ

2003 *29th Bradley National Print and Drawing Exhibition*
 Bradley University, Peoria, IL

2001, 2000 *Delta National Small Prints Exhibition*
 Arkansas State University, Jonesboro, AR
 The Discovery Museum, Bridgeport, CT

2001 *The Third Minnesota National Print Biennial*
 Weisman Art Museum, Minneapolis, MN

2001 *Sixty Square Inches: 13th Biennial National Small Print Exhibition*
 Purdue University, West Lafayette, IN

2001 *72nd Annual Connecticut Woman Artists Juried Show*
 The Discovery Museum, Bridgeport, CT

1997 *Look Both Ways Conant Gallery*, Lawrence Academy, Groton, MA

1996 *Pulse Points: Eastern Regional WCA Exhibition*
 Ticknor Gallery, Harvard Yard, Cambridge, MA

1994 *Pressing Matters*, Arts Center at Southborough, Southborough, MA

1994 *Woman Grossman Gallery*, School of Fine Arts, Boston, MA

1993 *Visual Contact Tisch Gallery*, Tufts University, Medford, MA

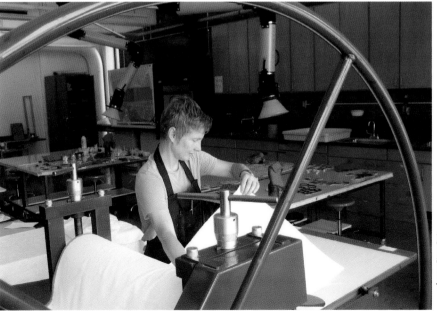

photo: Jian Cui

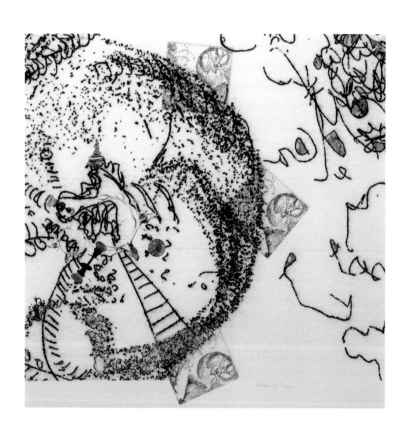

sum of the parts
 Collagraph and Intaglio
 85 separate prints varying sizes:
 22" x 22", 11" x 11", 6" x 6"

Minding the Gap
 Inkjet Prints
 22" high, 18' long

Come Close, Go Far
 12 at 24" x 24" Inkjet and Intaglio
 20 at 11" x 11" Intaglio and Photo Intaglio

Transference
 Inkjet, Intaglio, and Collagraph
 44 at 12" x 12"

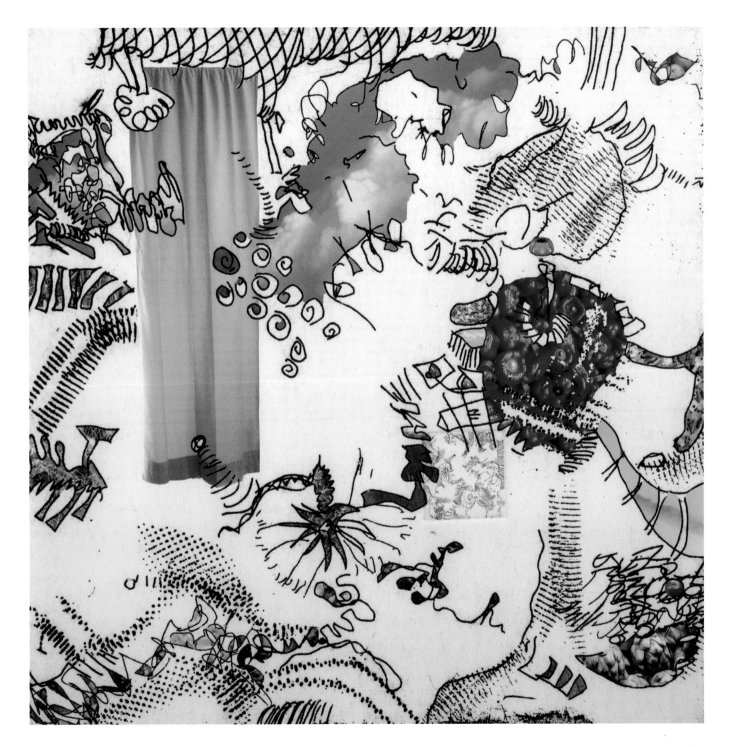

Table for Two from the *Come Close, Go Far* series 67

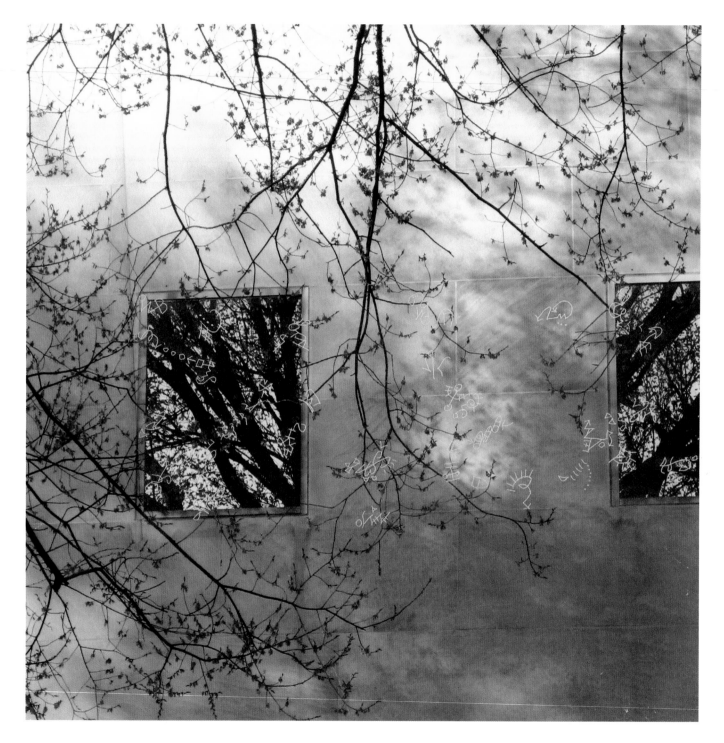

68 *Leap* from the *Transference* series

Photography by David Kenny of Studio 2029, Oneonta, NY

contourconnect@hotmail.com

Graphic Design by Alicia Opela of Binghamton, NY

alicia.opela@yahoo.com

Title Design by Ian Lascell

The typeface used is New Aster.

A generous grant from the Elizabeth Firestone Graham Foundation made the publication of this catalog possible.

ISBN 978-0-615-80129-2